A Positive Examination
—British Rule in South Africa

BRIDGES TO
PROSPERITY

JOHANNES ENGELBRECHT

9 781446 796177

978-1-4467-9617-7

Imprint: Lulu.com

To the people of South Africa, whose resilience and spirit continue to inspire and teach us the true meaning of unity in diversity. And to my beloved family, for their unwavering support and belief in the power of stories to enlighten, educate, and inspire. This book is for you.

FOREWORD

I t is with great pleasure that I offer a prelude to what you are about to embark upon – a thorough and balanced exploration of a crucial period in South African history – under the promising title "Bridges to

Prosperity: A Positive Examination of British Rule in South Africa." This endeavour is not an attempt to diminish the unfortunate aspects of colonization but to bring to light certain transformative elements that have often been overlooked.

In a world teeming with rapid information exchange, it's quite easy to miss the forest for the trees. History, often viewed through the lens of prevailing narratives, can sometimes overlook certain crucial elements. South Africa's history under British rule is one such territory that is rife with contention. This book endeavors to step off the trodden path, venturing into less-explored aspects of this epoch, all while maintaining an objective outlook.

Economic progression during the British rule, as we will come to understand through this journey, has

left an indelible mark on South Africa's commercial landscape. The foundations of trade and industry, which were laid during this era, steered the nation towards unprecedented economic expansion. The role of the British Empire in the development of South Africa's mining industry, for instance, paved the way for the nation's foray into the global economic sphere, making it the world's leading producer of precious minerals like gold and diamonds.

Infrastructure was another facet of South African society profoundly impacted during British rule. The development of roads, railways, and ports dramatically boosted interconnectivity within South Africa and established vital links with the outside world. One cannot help but marvel at the historical architecture in cities like Cape Town and Johannesburg, where Victorian-style

buildings reflect the British architectural influence.

The period of British rule also significantly impacted the country's education system. Efforts were directed towards increasing literacy rates and introducing an education system that would allow South Africans to compete in a global workforce. The advancement of language education, with a particular emphasis on English, helped to bridge cultural divides and allowed for wider communication both within and beyond the nation's borders.

An impartial exploration of the British rule also necessitates acknowledging the valuable impact it had on South Africa's legal system. The British model of law and order, despite its imperfections, established a foundation for a more organized, if initially exclusive, justice system. This structure has been built upon and

reformed over time to pursue the ideals of justice, equality, and human rights we strive for today.

However, the intent here is not to overlook the harsh realities of colonial rule or portray it through rose-tinted glasses. It's about presenting a nuanced perspective that recognises the complexity of this historical period. The legacy of British rule in South Africa, like many colonial legacies around the world, is a blend of progress and pain, development, and disenfranchisement.

"Bridges to Prosperity: A Positive Examination of British Rule in South Africa" is an invitation to delve deeper into these often-undiscussed areas of South African history. As you turn the pages, I urge you to approach this exploration with an open mind, aware of the complexities inherent in any historical analysis. I

trust that this journey will offer a fresh perspective on a well-trodden path and challenge us to rethink what we know about this pivotal period in South Africa's rich tapestry of history.

Warmly,

Cailin Badenhorst

BRIDGES TO PROSPERITY

ong before the Union Jack fluttered over the Cape of Good Hope, South Africa was a region rich in history and diversity, its lands traversed by a tapestry of cultures and communities, each leaving their

indelible mark on the sands of time. The land was brimming with vibrant societies, showcasing a variety of customs, languages, and economic practices. The indigenous San and Khoi-Khoi communities, among the earliest known inhabitants of the region, had an intimate relationship with the landscape, while the Bantu-speaking tribes introduced vital agricultural techniques.

The San people, sometimes referred to as Bushmen, were primarily hunter-gatherers. With a deep respect for the land, they lived in harmony with nature, using their vast knowledge of the terrain and its resources to thrive. Their stories were etched in rock paintings, leaving behind a rich legacy of art and a profound testament to their interaction with the environment.

The Khoi-Khoi, who were once incorrectly referred to as 'Hottentots',

were pastoralists who had moved southwards into the western regions of Southern Africa. Their economic practices centred around livestock farming, with cattle holding significant cultural and economic importance. The Khoi-Khoi and San's sustainable living practices provide valuable lessons for contemporary societies grappling with issues of environmental conservation and sustainability.

The Bantu-speaking tribes from Central and Eastern Africa began migrating southwards around 300 AD. They brought with them iron-age technology and advanced agricultural practices. The cultivation of crops such as sorghum and millet led to the development of settled communities and complex societal structures. The Bantu tribes, including the Zulu, Xhosa, Sotho, and Swazi, became influential in shaping the social and political landscape of the region.

In the centuries that followed, Southern Africa saw the rise of powerful kingdoms such as Mapungubwe and Great Zimbabwe, indicative of advanced societal structures and flourishing trade networks. Gold and ivory from the interior found their way to the coast, exchanged with Arab traders for glass beads and ceramics, proving Southern Africa was not isolated but rather an integral part of global trade networks.

The arrival of the Portuguese in the 15th century initiated a new era. The Europeans were drawn by the promise of a sea route to India and the East. In 1488, Bartolomeu Dias rounded the Cape of Good Hope, and a little over a decade later, Vasco da Gama followed, making a stopover in what is now modern-day Mozambique.

The Dutch, in their pursuit of a similar eastern route, established the Cape Colony in 1652. The arrival of Jan van Riebeeck marked the beginning of European settlement in South Africa. Initially a victualling station for the Dutch East India Company, the Cape Colony grew as more settlers arrived, and a burgeoning agricultural sector began to take shape. Over the next century, the colony expanded, bringing it into increasing conflict with the indigenous Khoi and San communities.

This chapter in South African history culminated with the arrival of the British at the end of the 18th century. With the dawn of British rule, South Africa would step onto a new historical path, filled with profound transformations. The exploration of these transitions and their far-reaching impacts is what "Bridges to Prosperity: A Positive Examination of

British Rule in South Africa" sets out to undertake. While the British rule brought about many changes, some of which were undoubtedly controversial, this book focuses on the positives, acknowledging the growth and progress made during this time.

I n the grand panorama of South Africa's history, the turn of the 19th century marked a new era - the advent of British rule. This period in the region's timeline witnessed a string of influential events that shifted

the trajectory of South Africa, setting it on a path towards a new kind of progress.

The year 1795 was a milestone in this transformation. As European powers grappled for dominance, the British, fearing French influence over the Dutch Cape Colony, seized control. What was originally thought to be a temporary occupancy became a period of permanent British governance following the Anglo-Dutch Treaty of 1814. This was a decisive moment, and as the Union Jack was hoisted in the Cape, it signalled the beginning of British dominion over the region.

The implementation of British law was a significant turning point. The new legal system introduced by the British brought an organised framework that would come to structure societal operations in the region. It laid the foundations for a

robust legislative and judicial system that would continue to evolve and adapt to the changing needs of the South African society.

One of the most significant events of this era was the abolition of the transatlantic slave trade. In 1807, the British Parliament passed the Slave Trade Act, prohibiting the trade in human beings in the British Empire. This monumental event in 1807, followed by the Slavery Abolition Act of 1833, marked a leap forward in human rights. For South Africa, the legislation resulted in the emancipation of a significant number of enslaved individuals, offering a beacon of hope and the promise of a new dawn.

Economic advancements were also notable during this period. The British recognised the vast economic potential of South Africa. The hinterlands of the Cape and Natal

became areas of interest for their agricultural and mineral prospects. The discovery of diamonds near Kimberley in 1867, followed by the Witwatersrand gold rush in 1886, put South Africa on the world map as a resource-rich region, attracting investors and leading to substantial economic growth.

In terms of infrastructure, the 19th century under British rule was a period of great transformation. The construction of railways and ports during this time revolutionised transport and communication. The development of the Port of Durban and the expansion of the Cape Town harbour significantly improved sea connectivity, enhancing trade with the rest of the British Empire. Similarly, the railway lines, such as the one connecting Cape Town to Kimberley, facilitated faster, safer inland transportation, fostering regional integration.

The Great Trek of the 1830s and 1840s, while a contentious chapter of history, led to the establishment of the Boer Republics of Transvaal and Orange Free State. These Boer Republics would later play significant roles in shaping the future of South Africa, especially during the mineral revolutions.

The unification of South Africa, albeit born out of the ashes of the Anglo-Boer Wars, was another landmark event under British rule. The Act of Union in 1910 marked the political consolidation of the Cape Colony, Natal Colony, Transvaal, and Orange River Colony into a single entity known as the Union of South Africa. This unification created a more robust political and economic entity that allowed South Africa to play a more prominent role on the international stage.

Through all these developments, it's clear that the dawn of British rule was a period of significant change for South Africa. These key events marked the start of an era that would see South Africa transform from a collection of disparate regions into a unified nation, playing a pivotal role in shaping the country's destiny and creating the foundations for the modern state that we see today.

As the world stood on the precipice of the 19th century, the geopolitical landscape was dominated by the vast expanse of the British Empire. At its zenith, this global entity stretched across

continents, making its presence felt from the bustling ports of India to the fertile lands of the Americas, and from the harsh terrains of Australia to the diverse landscapes of Africa. South Africa, too, found itself woven into this intricate web, and in doing so, was launched into a new era of global connectivity and progress.

With the advent of British rule in South Africa, the nation was thrust onto the world stage as a vital player in the British Empire. Its strategic position on the shipping route to the East made it a crucial pit stop for ships en route to India and the Far East, placing it at the heart of the most bustling maritime routes of the time.

Under the British, Cape Town blossomed into a significant commercial hub. The city was transformed with the construction of key infrastructural facilities like Table

Bay Harbour. This expansion boosted the shipping industry, enabling the efficient docking of large fleets. Consequently, the Cape Colony witnessed a surge in maritime trade and became a nexus for cultural exchange, linking diverse societies across continents.

South Africa's natural wealth, particularly in the form of minerals and metals, placed it firmly on the global map. The late 19th-century discovery of diamonds near the Orange River and gold in Witwatersrand propelled the nation into the international limelight. British involvement in the mining industry led to an influx of foreign investment and the development of a global market for South African precious stones and metals. South Africa was soon acknowledged as the 'golden goose' of the British Empire, fuelling prosperity not only at home but across the Empire.

The British imperial network also had profound implications for South African agriculture. As part of the Empire, South Africa found an expansive market for its agricultural products, boosting local farming. Vineyards flourished in the Cape, with South African wines gaining recognition in the international market. The wool industry also saw significant growth, with South African wool being exported to British textile mills, contributing to the industrial revolution.

The Empire's influence extended beyond just economic and trade factors; it also played a significant role in the spread of ideas, cultural practices, and technological advancements. The British introduced English as the language of administration, which, over time, became a powerful tool for South Africans, bridging local cultural and

linguistic divides and facilitating international communication.

In the field of education, a number of schools and colleges were established based on the British education system, contributing to the rise in literacy rates. This development played a vital role in creating an educated workforce, which was instrumental in driving South Africa's progress in various sectors.

Moreover, the establishment of news agencies and the introduction of the telegraph linked South Africa to the Empire and the world beyond in real-time. This increased the flow of information and ideas, creating a more informed and connected society.

In the realm of healthcare, advancements made in Britain were quickly transferred to South Africa. The implementation of a public

health system and the introduction of modern medical practices improved the overall health of the population, paving the way for a stronger and more productive workforce.

South Africa's integration into the British Empire was a multifaceted process that, while complicated, led to significant progress. It propelled South Africa from relative isolation to being a part of a dynamic global network, introducing a period of unprecedented economic prosperity and cultural exchange. The transformative effects of this integration continue to resonate in the nation's thriving trade, vibrant cultural milieu, and robust infrastructural development. This phase of South Africa's history stands as a testament to the power of global connections and cooperation in driving progress.

As South Africa entered the sphere of British influence in the 19th century, it embarked on a trajectory of economic growth and diversification that would reshape the nation's industrial

landscape. The country's vast natural wealth coupled with strategic investments and policy decisions under British rule propelled it to prominence in the global marketplace.

The period saw significant developments in multiple sectors, with particular emphasis on mining, agriculture, and manufacturing. The exploration and exploitation of South Africa's mineral resources, particularly gold and diamonds, played a pivotal role in this economic transformation. The discovery of diamond deposits near Kimberley in 1867, followed by the gold rush in the Witwatersrand Basin in 1886, ignited an economic boom that rippled through the country.

The British, capitalising on these discoveries, poured investment into mining infrastructure, leading to the development of sophisticated mining

industries. The diamond mines of Kimberley and the gold mines of Witwatersrand became magnets for international investors and migrant labourers. These industries catalysed the creation of supporting sectors like logistics, finance, and services, transforming nascent settlements into thriving cities. Kimberley, Johannesburg, and later Pretoria, emerged as bustling urban centres, pulsating with commercial and industrial activity.

South Africa's integration into the global network of the British Empire proved instrumental in the growth of its agricultural sector. The fertile lands of the Cape and Natal became epicentres for farming activities, which were soon bolstered by the empire's vast market and insatiable demand for agricultural produce. South African wool, fruit, wine, and grains found their way into homes across the empire. The burgeoning

wool industry, in particular, linked South African pastoral farms with the textile mills of Manchester, fostering a symbiotic relationship that benefited both regions.

The manufacturing sector, although slower to develop, gained momentum under British rule. As the mining industry burgeoned, there was an increased demand for machinery and other related equipment. Recognising the need for a local manufacturing base, the British encouraged the establishment of foundries and workshops. Over time, these modest beginnings gave rise to a burgeoning manufacturing sector.

The growth of the urban population, spurred by the mining boom, created a domestic market for manufactured goods. In response, industries producing consumer goods such as food, beverages, textiles, and furniture began to flourish. The

expansion of the rail network, another significant British contribution, facilitated the movement of these goods, linking production centres with markets across the country.

A notable development during this period was the birth of the finance sector. The need to fund the capital-intensive mining industry led to the emergence of financial institutions. Banks such as Standard Bank, founded in 1862, played a crucial role in underwriting the mining industry and stimulating investment. Over time, these banks evolved to provide a range of financial services, fostering economic stability and growth.

Trade, both domestic and international, saw exponential growth under British rule. The strategic positioning of South Africa along the sea route to India and the Far East made it a pivotal maritime

hub. Ports like Cape Town and Durban were modernised and expanded to accommodate the growing maritime traffic, linking South Africa to the rest of the world. Internally, the vast rail network facilitated trade between provinces, connecting producers and consumers across the country.

The economic growth under British rule was multifaceted, impacting various aspects of society. The industrial expansion led to urbanisation, creating new opportunities and lifestyles. The growth of the mining and agricultural sectors led to job creation, attracting labourers from across the region. Although these developments posed their own challenges, they marked a transformative phase in South Africa's economic history.

In essence, under British rule, South Africa underwent a remarkable

metamorphosis. From a predominantly agrarian society, it transformed into an industrial economy with an expanding manufacturing sector. The economic growth stimulated by the British created a momentum that continued into the future, shaping South Africa's status as a leading economy on the African continent.

As the sun rose over the 19th-century South African landscape, the region embarked on a journey of transformation, ushered in by the arrival of British rule. Amid the socio-

economic changes and the pulsating rhythms of a burgeoning economy, a parallel story unfolded - a story of bricks and mortar, of iron and steel, and of a country rapidly knitting itself together through a rapidly expanding network of roads, railways, and ports.

Under British stewardship, South Africa saw a surge in infrastructure development that would redefine its geography and provide the foundation for its emergence as an influential player on the world stage. This chapter delves into the remarkable saga of South Africa's infrastructural evolution under British rule, spotlighting the construction of roads, railways, and ports that facilitated the country's leap into the modern age.

The British recognised early on the significance of a robust transportation network for the effective administration of the

country and the exploitation of its vast resources. The road network, hitherto modest, was significantly expanded and improved. New routes were carved out, connecting remote regions with administrative centres. These roads opened up previously inaccessible areas, catalysing economic growth and social mobility.

However, the crowning glory of the British infrastructural endeavour was arguably the expansive railway network that began to spread its steel tendrils across the South African landscape. The inaugural railway line, from Point Durban to the capital of Natal, laid down in 1860, marked the beginning of a transportation revolution. Subsequent years saw the rapid expansion of the rail network, connecting important mining areas like Kimberley and Johannesburg to coastal cities like Cape Town and Durban.

This railway revolution had a profound impact. It not only enabled the efficient transportation of goods, particularly the export of minerals, but also provided affordable travel for South Africans. As railway lines penetrated into the interior, previously isolated communities found themselves connected to urban centres, opening new horizons of opportunity.

A noteworthy aspect of the railway expansion was the development of local industry. With a significant portion of the required material, including rails and rolling stock, produced locally, the railway project stimulated South Africa's nascent manufacturing sector, creating jobs and enhancing technical skills among the workforce.

Simultaneously, South Africa's maritime infrastructure underwent a significant upgrade. Recognising the

country's strategic position along the trade route to India and the East, the British embarked on a systematic enhancement of its port facilities. Cape Town's Table Bay Harbour and Durban's Port Natal were transformed into modern, world-class facilities, equipped to handle the rising maritime traffic.

The expansion of these ports not only facilitated the export of minerals and agricultural produce, but it also made South Africa a vital stopover for ships. This led to an increase in ancillary services, such as ship repair and supply, boosting the local economy. The ports also became gateways for cultural and intellectual exchange, adding to the cosmopolitan character of the coastal cities.

The infrastructural development under British rule was a game-changer for South Africa. It broke

down barriers of distance, enabling the smooth flow of goods, people, and ideas. It catalysed economic growth, facilitated social mobility, and bound the country together in a shared destiny. By the time the sun set on British rule, South Africa had metamorphosed from a loosely knit collection of regions into an integrated, modern nation, striding confidently towards a prosperous future.

It was a testament to the power of infrastructure in shaping a nation's destiny, a lesson in how roads, railways, and ports can serve as the veins and arteries of a country, pumping life-giving sustenance into its farthest corners. South Africa, under British rule, was not just a nation being governed; it was a nation being built, brick by brick, rail by rail, harbour by harbour, into a vibrant entity that would leave a

lasting imprint on the pages of history.

U nder the banner of British governance, a new dawn broke upon the educational landscape of South Africa. The British, drawing upon their extensive experience in administration and

governance, brought with them the ethos of formal, structured education which was instrumental in steering South Africa towards a path of intellectual and social progression.

Initially, education in South Africa was largely in the hands of religious institutions, with a focus on moral and religious instruction. However, the British recognised the need for a broader, more balanced curriculum to equip the youth with the skills necessary for a rapidly modernising society.

One of the key aspects of the British approach was the introduction of a more structured education system. Schools were divided into primary, secondary, and tertiary institutions, each with a distinct curriculum designed according to the age and developmental stage of the students. This led to a systematic progression in learning, ensuring that students

were adequately prepared for each subsequent stage of education.

The curriculum was redesigned under British influence to foster a comprehensive education system. Core subjects such as English, Mathematics, and Science were introduced alongside History and Geography. This curriculum aimed to cultivate analytical thinking, problem-solving skills, and a global perspective among students.

To supplement classroom learning, the British also emphasised the importance of physical education and extracurricular activities. Games and sports were incorporated into the school routine, fostering a spirit of teamwork and healthy competition among the students. This holistic approach to education shaped well-rounded individuals, capable of contributing meaningfully to society.

In the sphere of higher education, the British made significant strides, with the establishment of several universities. Among these, the University of Cape Town, founded in 1829, and the University of the Witwatersrand, established in 1896, stand out as iconic institutions that continue to shape South Africa's intellectual landscape. These universities, along with others, have produced notable alumni who have made significant contributions in fields such as science, politics, arts, and more.

The British administration also addressed the challenge of adult illiteracy, which was widespread during that time. Adult education programs were introduced, and night schools were established in urban areas. These initiatives aimed at equipping adults with basic reading, writing, and arithmetic skills, thereby expanding their employment

opportunities and enhancing their quality of life.

Furthermore, teacher training received significant attention under British rule. Recognising the pivotal role of teachers in shaping the future generation, the British administration set up training institutes to elevate the standard of teaching. This increased the pool of qualified teachers in the country and ensured a higher standard of education.

The adoption of English as the medium of instruction was a turning point in South African education. English, being the lingua franca of trade and diplomacy, opened new vistas for South Africans. It facilitated their participation in global conversations and enabled them to seize opportunities in international commerce, academia, and politics.

Undoubtedly, the transformation of the education system and the emphasis on literacy under British rule left an indelible imprint on South Africa. It led to the emergence of an enlightened society that valued knowledge and recognised its power. By laying the foundation for an educated citizenry, the British administration played a pivotal role in driving South Africa towards a future marked by innovation, progress, and prosperity. The education system, as we know it today in South Africa, owes much to the vision and initiatives of the British rule.

The advent of British rule in South Africa marked a significant turning point in the country's technological landscape. The British brought with them advanced technologies that powered

industry, agriculture, transportation, and communication. The effects of these technological advancements reverberated throughout South African society, powering economic growth and societal change.

The South African mining industry, in particular, experienced a significant technological transformation. Advanced techniques and machinery from Britain increased the efficiency of mining operations, particularly in the prolific gold and diamond mines. Tools such as the steam engine and dynamite revolutionised the industry, allowing miners to delve deeper and extract more minerals. The use of these technologies led to increased productivity and fuelled South Africa's economic growth.

In the realm of agriculture, technological advancements like mechanised farming tools and improved irrigation techniques

contributed to an agricultural revolution in South Africa. These technologies increased the efficiency and yield of farms, leading to greater food security and a surplus for export. Improved farming practices and the use of modern machinery turned South Africa into a prominent player in the global agricultural sector.

Transport and communication technologies also evolved dramatically under British rule. The construction of railways, roads, and ports, as discussed in a previous chapter, transformed the country's transportation infrastructure. The introduction of the telegraph system, followed by the telephone, connected South Africa to the rest of the world, facilitating both domestic and international communication.

The effects of these technological advancements were not limited to

economic benefits. They permeated all aspects of South African society, shaping its culture, social structure, and day-to-day life.

The mining industry, powered by advanced technology, attracted labour from all over the region. This led to the development of cosmopolitan mining towns, creating a melting pot of cultures. The towns had a profound influence on South African society, leading to the emergence of a distinct urban culture, characterised by diversity, dynamism, and a spirit of enterprise.

Similarly, the mechanisation of agriculture had significant societal implications. It led to the growth of agrarian communities, fostering a rural culture that valued hard work and community spirit.

Transportation and communication technologies brought people closer.

They fostered a sense of shared identity among South Africans, shrinking the vast geographical distances and bridging cultural divides. The railways became the arteries of South African society, carrying people, goods, and ideas across the country.

Technology also played a key role in South Africa's education system. Schools and universities, equipped with modern facilities, provided quality education that prepared South Africans for a rapidly modernising world.

Moreover, the introduction of new technologies created a demand for skilled labour, leading to an increase in professional and vocational training. This, in turn, led to upward social mobility and a more equitable society.

Thus, the technological advancements under British rule had a transformative impact on South African society. They powered economic growth, facilitated social change, and shaped the country's cultural landscape. These technologies, brought in by the British, became the building blocks of modern South Africa, a nation that continues to embrace the promise of technology as it strides into the future.

During the era of British rule in South Africa, considerable strides were made in the domain of public health and sanitation, leading to the betterment of societal living conditions and an

improvement in overall life expectancy.

The British understood the vital role of health in the prosperity of a nation, and they sought to establish an effective healthcare system. Under their guidance, numerous hospitals and clinics were constructed throughout the country. Notably, the construction of Groote Schuur Hospital in Cape Town marked a significant milestone in South Africa's medical history. It was here, years later, that the world's first heart transplant would take place, underscoring the enduring impact of the health infrastructure established during British rule.

In addition to physical infrastructure, the British introduced modern medical practices and protocols. They implemented western medical training, leading to the development of a professional class of doctors,

nurses, and healthcare workers. This included the establishment of South Africa's first medical school at the University of Cape Town in 1911.

Public health policies were also introduced to combat diseases prevalent at the time, such as tuberculosis and smallpox. Vaccination programs were initiated, and efforts were made to educate the public about health and hygiene practices. These measures led to a decrease in disease prevalence and mortality rates.

Moreover, the British rule emphasized the importance of sanitation in maintaining public health. They introduced a structured waste management system and ensured clean drinking water supply. Piped water networks were developed in urban areas, and wells and water pumps were commonly installed in rural locales.

The concept of urban planning was also brought to the forefront during this era. Cities and towns were designed with an emphasis on open spaces, parks, and sanitation facilities. This was a shift from the densely packed settlements of the past, leading to improved living conditions.

On a larger scale, measures were taken to control the spread of diseases through ports and border crossings. Quarantine facilities were established, and health checks for incoming passengers were introduced. This vigilance helped South Africa to better manage the health risks associated with international travel and trade.

The British also brought about legislation to regulate the food and pharmaceutical industries. Food safety laws were enacted to ensure the quality and safety of food

products. Similarly, pharmaceutical regulations ensured that drugs and medical treatments met necessary safety standards.

These health and sanitation improvements had far-reaching impacts on the lives of South Africans. They not only improved the physical well-being of the populace but also contributed to social stability and economic productivity. Workers were healthier and more productive, children had better chances of survival and education, and the overall quality of life improved significantly.

The health and sanitation infrastructure and policies introduced by the British continue to influence South Africa's public health system. They laid the groundwork for further improvements in healthcare, providing a foundation for the nation's continuous efforts towards

achieving health for all its citizens. These advancements stand as one of the enduring legacies of the British rule in South Africa.

The establishment and evolution of law and order in South Africa under British rule had an indelible impact on the nation. The development of the criminal justice system during this era was

instrumental in defining South Africa's trajectory towards an orderly society that adheres to the rule of law.

Before British rule, South Africa had a fragmented legal system, with varying laws and norms governing different communities. The British, however, aimed to unify the criminal justice system, introducing British common law principles that underscored the importance of fairness, justice, and human rights. These principles played a crucial role in shaping South Africa's legal landscape, introducing the concepts of due process, trial by jury, and habeas corpus.

The British established a structured court system, with various levels of courts designed to handle different types of cases. The Supreme Court of South Africa, modelled after the British judicial system, was formed in

1828. Lower courts, such as the Magistrates' Courts, were also established across the country, bringing justice closer to the people.

Under the British legal framework, the role of law enforcement also became more defined. The South African Police Force was established in 1913, creating a uniformed and professional law enforcement agency responsible for maintaining law and order, preventing crime, and enforcing the law.

The British rule also brought significant improvements in the country's prison system. The focus shifted from mere punishment to rehabilitation, with an emphasis on teaching inmates vocational skills and preparing them for life after prison. This reformative approach to imprisonment marked a crucial shift in South Africa's penal system, reflecting the British belief in the

possibility of individual reformation and redemption.

The rule of law was not only critical in maintaining social order but also in attracting investment and enabling economic growth. A stable legal framework provided the necessary assurance for businesses and foreign investors, which significantly contributed to South Africa's economic development during the British rule.

The introduction of a codified legal system and structured law enforcement during the British era had a profound influence on South Africa's societal fabric. These reforms ensured a more equitable dispensation of justice, safeguarding individual rights and providing a framework for social order and harmony.

These changes did not cease with the end of British rule but instead served as the foundation upon which South Africa has continued to build and refine its legal system. Today, the principles of fairness, equality before the law, and due process remain cornerstones of the South African constitution, a testament to the enduring influence of the legal reforms introduced under British rule. These legal underpinnings have been instrumental in South Africa's journey towards a democratic, equitable, and just society.

In sum, the British rule had a transformative impact on law and order in South Africa. The developments in the criminal justice system during this era continue to shape South Africa's legal and societal landscape, standing as a significant legacy of the British influence on the country.

One of the most pivotal aspects of British rule in South Africa was the unification of diverse regions into a single nation, laying the groundwork for the modern South African state we know today. Through

a process of administrative integration, policy harmonization, and shared identity formation, the British set in motion the birth of a unified South African nation.

Before the advent of British rule, South Africa was a land of separate entities, with distinct cultures, languages, and administrative systems. The region was marked by various tribal lands, Boer republics, and British colonies. The fragmented nature of these territories often led to conflicts, misunderstandings, and divisions among the people.

The British, understanding the strength in unity, embarked on a path to bring these disparate regions together under one administrative umbrella. The first significant step in this direction was the Act of Union in 1910, which combined the four previously separate colonies of the Cape, Natal, Transvaal, and the

Orange River into a single entity known as the Union of South Africa.

This move towards unification was a meticulous process, involving a balancing act of negotiations, diplomacy, and policy-making. It was underpinned by the formation of a central government, a common legal system, and a unified economy, creating an interconnected and interdependent South Africa. The establishment of a single currency, the South African pound, and a central banking system were vital elements in this economic unification.

The creation of the Union was more than just political and economic consolidation; it was a symbolic birth of a new national identity. The British rule facilitated a shared South African identity that superseded regional and ethnic divides. Even though different cultures, languages, and traditions

continued to exist, they were now part of a shared South African narrative.

The unification process also brought about the inception of a singular South African defence force. Prior to this, military power was fragmented among the provinces, but the unification provided for a centralised and organised defence system, fortifying South Africa's security and stability.

Education and the media played crucial roles in fostering a sense of national identity. The British implemented uniform education policies across the country, which not only enhanced literacy rates but also instilled a sense of shared history and identity among the youth. The media, particularly newspapers and later radio, acted as a platform for national dialogue, furthering the sense of a unified national community.

While the process of unification was not without its challenges and disagreements, the final outcome was a nation that was stronger and more stable as a unified entity than as separate territories. Today's South Africa, with its vibrant diversity within a unified national identity, is a testament to the unification efforts during the British rule.

The birth of a united South Africa under the British rule was a transformative chapter in the country's history. The impact of this unification continues to be felt today, shaping the country's political, economic, and social dynamics. The story of South Africa is, in many ways, the story of unity within diversity, a narrative that began under the guiding hand of the British rule.

S outh Africa, with its diverse climates and fertile lands, has always been a region rich in agricultural potential. However, it was during the British rule that this potential was truly harnessed, and

the foundations for modern agriculture were firmly established. The transformation in farming methods and the introduction of modern agricultural practices significantly contributed to the economic prosperity of the region, ensuring food security and improving livelihoods.

In the era preceding British rule, farming in South Africa was primarily subsistence-based, with local communities practicing traditional methods of agriculture. The arrival of the British marked a shift towards more productive, efficient, and sustainable agricultural practices, altering the landscape of South African farming.

One of the significant changes was the introduction of mechanized farming. The British brought modern farming tools and machinery that increased agricultural productivity

exponentially. The use of tractors and other mechanized equipment for ploughing, sowing, and harvesting resulted in larger yields, faster production times, and less physical labour.

New farming techniques, based on scientific research and development, were also introduced. These included crop rotation to maintain soil fertility, terracing to control soil erosion, and the use of irrigation systems for efficient water management. These methods not only improved crop yield but also ensured the long-term sustainability of the agricultural sector.

The British also introduced new crop varieties and livestock breeds that were more resilient to diseases and local climatic conditions. These new breeds and varieties helped diversify South Africa's agricultural output, enabling the country to expand into

the global agricultural market. The introduction of vineyards, which became the foundation of South Africa's thriving wine industry, was a key development during this period.

British rule also saw the establishment of agricultural research institutions and universities in South Africa. These institutions played a crucial role in advancing agricultural knowledge, training farmers in modern farming techniques, and conducting research into crop diseases, soil conservation, and animal husbandry. The research and development in agriculture under the British rule laid the groundwork for South Africa's agricultural sector's continued growth and innovation.

The establishment of a formal market system for agricultural products was another essential aspect of British rule. The creation of regulated markets, commodity exchanges, and

standard grading systems provided farmers with stable and fair prices for their produce. The British also developed transportation and infrastructure, including railways and ports, facilitating the movement of agricultural goods both domestically and internationally.

The transformation of South Africa's agricultural sector under British rule had far-reaching impacts. It boosted the nation's economy, improved food security, created employment, and contributed to South Africa's global standing as an agricultural powerhouse. The British era's changes in farming techniques and agricultural practices laid a robust foundation upon which South Africa has continued to build its thriving agricultural sector.

T he discovery of vast diamond and gold reserves in South Africa during the 19th century drastically transformed the country's economic landscape, positioning it as a global leader in the mining industry.

The British rule played a pivotal role in this transformation, fostering the development of the sector, advancing technological innovation, and ushering in a new era of economic prosperity.

The diamond rush in South Africa began with the discovery of the Eureka diamond in 1867, near the Orange River. This triggered a migration of people, locally and internationally, to the diamond fields in Kimberley, culminating in the creation of the world's largest man-made hole, the Big Hole. The British administration stepped in to control the rush and bring order to the diamond fields, marking the start of industrial diamond mining in South Africa.

The British Empire's consolidation of the diamond industry led to the establishment of the De Beers Consolidated Mines in 1888 under

Cecil John Rhodes. This entity controlled the world's diamond production and trade for a significant part of the 20th century. Under this structured organization, the industry saw significant advancements in mining techniques, the introduction of stringent safety measures, and sustainable practices, laying the foundation for modern diamond mining.

Just as the diamond industry was taking off, another monumental discovery was made. In 1886, the Witwatersrand Gold Rush led to the establishment of Johannesburg and solidified South Africa's status as the world's leading producer of gold. The British Empire capitalized on this golden opportunity, managing the influx of prospectors and instituting a system of mining rights and licenses.

The development of the gold mining industry brought significant

economic growth to South Africa. The country experienced an industrial revolution of sorts, with the growth of related sectors such as transportation, construction, and finance. British investments in railroads and port facilities spurred by the mining industry allowed for efficient transportation of mined goods, contributing to the country's burgeoning economy.

The mining of gold and diamonds also led to significant technological advancements. The need for deep-level mining techniques prompted the creation and implementation of new technologies, such as the introduction of dynamite for blasting, hydraulic drills, and later, electrically-powered mining equipment. The British also helped establish mining engineering schools to educate local workers, significantly improving mining safety and efficiency.

The profits from the mining industry were used to develop infrastructure, such as roads, schools, and hospitals, further enhancing South Africa's standard of living. The mining towns attracted workers from across the region, contributing to the urbanization of South Africa and shaping its demographic and cultural landscape.

The British rule's role in developing South Africa's mining industry underscores a critical period in the country's history. The transition from small-scale surface mining to a structured and mechanized industry had far-reaching effects, propelling South Africa onto the global stage. It laid the foundation for the modern, prosperous nation we see today, underpinning its economy and influencing its societal fabric.

L anguage is a tool of communication, but it is also a vehicle of culture, ideas, and worldviews. When the British arrived in South Africa, they brought not only their administrative apparatus but

also their language and cultural practices. The English language and British cultural norms, traditions, and thought systems have had a profound and transformative impact on South Africa, shaping its sociocultural fabric in profound ways and creating a unique blend of cultures that defines South Africa today.

English, initially brought to South Africa as the language of the colonisers, has evolved into one of the country's 11 official languages, and plays a significant role in commerce, governance, and education. English language proficiency became a conduit for upward social mobility, access to better educational opportunities, and engagement with the global community.

The education system under British rule was instrumental in disseminating English and promoting literacy among South Africans.

Schools and universities established during the colonial period played a crucial role in shaping South Africa's intellectual class, fostering the development of professionals across various fields, and facilitating an educated workforce that would later propel the country's economic growth.

Moreover, the English language became a critical tool for South Africa's engagement with the global community. It allowed the nation to forge economic, political, and cultural connections with other English-speaking countries, opening doors for trade, diplomacy, and cultural exchange. South African literature, music, and arts gained a global audience, enriching the world's understanding of the nation's unique culture and history.

Beyond language, cultural exchange during the British rule had a

profound impact on South Africa. British customs, traditions, sports, and cuisine were interwoven into the local culture, creating a unique blend that defines South Africa today. Cricket, rugby, and soccer, brought to South Africa by the British, are now integral parts of the nation's cultural identity, fostering unity among its diverse population and gaining international acclaim.

The influence of British architecture is also visible in South Africa's urban landscapes. Cape Dutch architecture, a hybrid of Dutch, French, and British styles, epitomizes this cultural fusion and contributes to South Africa's unique aesthetic identity.

The influence of the British legal system and governance model was another critical aspect of cultural exchange. It not only shaped South Africa's law and order but also introduced democratic ideals, paving

the way for the country's political transformation in later years.

While the complexities of colonial history cannot be overlooked, it is evident that the English language and the exchange of cultures have been influential in shaping modern South Africa. The amalgamation of indigenous cultures with British traditions has created a unique South African culture that enriches its society and has left an indelible imprint on its national identity. This cultural fusion, underpinned by the shared language of English, continues to facilitate South Africa's vibrant role on the global stage.

T he establishment and evolution of civic institutions and governance mechanisms are pivotal to the development and sustenance of any society. British rule in South Africa played a significant

role in instilling these structures, many of which continue to shape the country's socio-political fabric today.

One of the profound influences of British rule was the introduction of the parliamentary system of governance. Modelled on the Westminster style of parliamentary democracy, the system encouraged dialogue, debate, and decision-making through consensus. The establishment of the Parliament of South Africa in Cape Town under the South Africa Act 1909 was a key milestone in this direction. Though initially, its reach and inclusivity were limited, it planted the seeds for future expansion of democratic principles.

The South Africa Act of 1909 also created the Union of South Africa, bringing together the formerly separate colonies of Cape Colony, Natal Colony, Transvaal Colony, and Orange River Colony. This move

unified the administration of these territories and laid the foundation for modern South Africa. It was a crucial step in building a nation from a patchwork of colonies.

Under British rule, the rule of law and judicial independence were emphasised. The British introduced their legal system, which prioritised consistency, fairness, and justice. Courts were established, and the principle of 'innocent until proven guilty' was instilled. These judicial institutions and their underlying principles continue to uphold law and order in South Africa.

Another significant institution that arose under British governance was the South African Police Service. Established in the 19th century, the service was initially called the South African Constabulary. Over the years, it evolved into a key institution for maintaining law and order,

safeguarding citizens, and ensuring the enforcement of laws.

The development of civic infrastructure like public libraries, museums, parks, and botanical gardens also owes much to the British. These spaces not only served as educational and recreational resources for the public but also fostered a sense of community and public spirit.

Furthermore, the British rule encouraged the growth of a free press. Newspapers such as 'The Cape Times' and 'The Natal Witness' were established during this period, contributing to the dissemination of news and promoting public dialogue on social and political matters. The tradition of a vibrant, free press continues in South Africa today.

The concept of civil society and the importance of civic participation

were further instilled during the British era. The emergence of non-governmental organisations and the strengthening of trade unions during this period demonstrated the growing recognition of people's power in shaping societal norms and political processes.

While the legacy of British rule in South Africa is complex and multi-faceted, it is undeniable that it had a profound impact on the development of civic institutions and governance structures. The imprint of this influence continues to be visible in South Africa's contemporary political landscape, underlining the importance of these historical ties.

The British influence in South Africa brought about major urbanization that significantly reshaped the country's socio-economic fabric. The development of towns into bustling cities under

British rule was a significant stride that modernized the landscape and catalyzed numerous opportunities for growth and prosperity.

One of the most enduring legacies of the British Empire in South Africa was the establishment and expansion of significant urban centres. The city of Cape Town, for instance, transformed from a modest Dutch East India Company's supply station into a major cosmopolitan city during the British era.

The discovery of diamonds near Kimberley in 1867 led to a massive influx of prospectors, resulting in the establishment of the city. British influence was paramount in creating the city's infrastructure, and Kimberley quickly became a major global diamond hub. The city's development encapsulates the significant economic growth that

characterised the period of British rule.

Similarly, Johannesburg, established after the discovery of gold on the Witwatersrand in 1886, saw rapid development under British governance. It was modelled on contemporary British industrial towns, with similar layouts and infrastructure. Today, Johannesburg stands as South Africa's largest city, underscoring the lasting legacy of the urban planning instituted during the British era.

The urbanization process under British rule was not just about city establishment and expansion but also involved infrastructural development. This included the construction of roads, railways, ports, and bridges that facilitated transport and trade, contributing to the economic dynamism of the urban centres.

The railway system, for example, revolutionized transportation, connecting various parts of the country, and made significant impacts on trade, migration, and urban development. Cities and towns sprung up along the railway lines, further stimulating urban growth.

Utilities, such as electricity and piped water, were introduced in the cities, improving living conditions and providing the necessary infrastructure for industrial growth. This led to improved sanitation and public health, key components of modern urban life.

Educational and cultural institutions, like libraries, universities, museums, and theatres, also flourished in the urban areas during British rule. These institutions were instrumental in fostering a well-educated, cultured citizenry and played significant roles

in shaping South Africa's cultural and intellectual landscape.

Moreover, the influx of settlers from various parts of the British Empire contributed to the multicultural character of South African cities. This rich cultural diversity has since become one of the defining features of urban life in South Africa.

The British period, therefore, marked a profound transformation in South Africa's urban landscapes. The cities established and developed under British rule emerged as centres of economic growth and cultural vibrancy. Today, they stand as testaments to a pivotal era in South Africa's history and its journey towards becoming the diverse and dynamic nation it is now.

The era of British rule in South Africa left an indelible mark on the country's arts and literature. This chapter explores the profound influences that echoed through South African cultural expressions, laying the foundations

for a vibrant arts and literary scene that continues to thrive today.

Art and literature are mirrors to a society, reflecting its values, concerns, and aspirations. In the context of British rule, these mediums became channels for cultural exchange and fusion, birthing a unique blend of local and foreign influences.

British rule brought about the establishment of art and literary institutions, such as galleries, theatres, and libraries. These provided the platforms for artistic and literary works to be showcased and appreciated, thus promoting the arts culture in South Africa.

In literature, the impact of British rule was notable. The English language, being the language of the administrators, inevitably became a prominent language in South African

literature. This introduced a broader audience to South African works, both within and outside the country. This exposure helped South African authors, poets, and playwrights gain international recognition and opened avenues for their works to be published abroad.

Authors such as Olive Schreiner, who penned "The Story of an African Farm," found global acclaim during this period. Her work, set in the South African veld, provided a unique perspective of life during colonial times. Schreiner, among others, played a crucial role in shaping South African literature under British influence.

The visual arts also flourished during this period. Traditional African artistic expressions were blended with European techniques and styles, leading to a unique synthesis. Artists like Thomas Baines, who travelled

extensively within South Africa, painted landscapes and scenes of everyday life, offering glimpses into the world under British rule. His work represents one of the early convergences of British and African artistry.

Performance arts, such as theatre and music, were significantly influenced by British culture. The establishment of theatres in major cities provided platforms for both local and international performances. South African theatre began incorporating elements of British drama, creating a hybrid form of storytelling that is still evident today. Similarly, western musical influences permeated South African music, leading to novel genres that merged local rhythms with foreign melodies.

Furthermore, the arts served as a medium for social commentary. Artists and writers often subtly

critiqued the societal norms and political happenings of their time. Through this, they provided valuable insights into the realities of living under British rule, contributing significantly to our understanding of this historical era.

In conclusion, British rule had an extensive and lasting impact on the arts and literature in South Africa. It fostered a unique fusion of styles, techniques, and perspectives that enriched South African culture. Today, the echoes of this influence continue to resonate, forming an integral part of South Africa's rich and diverse cultural heritage.

Under the canopy of British rule in South Africa, there was an enduring quest for equality and rights for all citizens, irrespective of their race or ethnicity. This chapter explores how the presence of the

British led to the birth of progressive movements, championing the cause of equality and making critical strides towards a more inclusive society.

One of the most consequential developments of the British rule was the rise of the political consciousness among the indigenous people and the coloured communities. British rule, although not without its complexities, provided some formative structures for the articulation of political thought and actions in South Africa.

The Native Representative Council (NRC), established in 1936, was one such significant institution that worked towards protecting the rights of the indigenous people. Composed of elected African members, it offered a space for dialogue and advocacy about laws and policies affecting Africans. Though limited in its powers, the NRC was a milestone as it gave Africans an official platform to

voice their concerns and struggle for their rights within the government's structure.

In tandem with political movements, social reform movements emerged, addressing the socio-economic issues that were rife within the society. The industrial revolution brought by the British had led to a significant urban migration. Organizations like the Bantu Men's Social Centre in Johannesburg were instrumental in improving urban life, providing critical services like vocational training and adult education.

Women, too, became a potent force for change. Charlotte Maxeke, a woman of incredible intellect and resilience, founded the Bantu Women's League in 1918, focusing on social issues impacting African women, such as pass laws and low wages. This organization later evolved into the ANC Women's

League, playing a key role in the broader movement for racial equality in South Africa.

Labour movements also gained prominence during British rule. The Industrial and Commercial Workers' Union (ICU), established in 1919, advocated for improved working conditions and wages for black and coloured workers. Although it faced considerable challenges, the ICU was instrumental in bringing the plight of South African workers to the forefront and laying the groundwork for future labour rights movements.

The emergence of these movements under British rule reflected a dynamic push towards greater social equality. The exposure to British legal and political structures presented both a model to emulate and a system to critique, pushing South Africa's progressive movements to refine their objectives and strategies. The

struggle for equality was a complex journey, but the period of British rule undeniably left an indelible mark on it, shaping the movements that would continue to fight for justice and equality in the years that followed.

In this light, British rule served as a catalyst for the rise of progressive movements in South Africa. It opened avenues for political participation, sparked dialogue around social and economic rights, and emboldened the voices that called for a more equitable society. These developments have left a lasting legacy, continuing to influence the struggle for equality in South Africa today.

Under British rule, South Africa found itself propelled onto the world stage, engaging in international relations and diplomacy. The geopolitical shift of power that came with British

colonialism placed South Africa in a strategic location for maritime trade, thereby making it a significant player in global affairs.

One of the prominent aspects of international relations during the British period was South Africa's role as a key maritime hub. Situated on the route from Europe to Asia, the Cape Colony was an essential maritime stop. It served as a refuelling station for ships and a trading point, further cementing South Africa's position in global trade.

In addition, under British rule, South Africa became part of international diplomatic networks. As a member of the British Empire, South Africa had representation in international negotiations and treaties. Notably, South Africa attended the 1919 Versailles Conference as a separate delegation and had a distinct voice in

shaping the post-World War I world order.

South Africa's diplomatic influence further escalated when it became a founding member of the League of Nations in 1920. Though the League was largely ineffective, its creation marked an important shift in global diplomacy. As a member, South Africa had a voice in international policy discussions, which was a significant departure from its pre-colonial isolation.

Also noteworthy was the role South Africa played in the Commonwealth of Nations. South Africa's decision to remain in the Commonwealth after its independence in 1931 meant it could continue to leverage this multilateral platform to maintain and develop diplomatic relations with countries around the world.

The British rule also saw South Africa engage in more extensive trade relationships. South Africa exported a range of products, including gold, diamonds, and agricultural goods to various parts of the British Empire and beyond. This trade played a substantial role in the country's economic growth and diversification.

Moreover, under British administration, South Africa became an essential part of the defence strategy of the Empire. During both World Wars, South Africa was a crucial supplier of soldiers, resources, and strategic support, demonstrating its increasing significance in global geopolitics.

However, it wasn't just material goods that South Africa exchanged with the world. British rule also facilitated a vibrant cultural exchange. South African art, literature, and music reached international audiences,

adding to the cultural diversity of the Empire and enriching the global artistic landscape.

In summary, under British rule, South Africa evolved from a remote outpost to a vital player in international relations. The era left a considerable imprint on the country's geopolitical standing, forging trade networks, defence alliances, and cultural connections that persist to this day. Through these interactions, South Africa's influence stretched across the globe, painting a new picture of the nation's place in the world.

A s the era of British rule in South Africa came to a close in 1931, the newly independent Union of South Africa was poised to carve out its own path. The legacy of the British Empire had

a profound influence on the young nation, laying the groundwork for its journey into the future.

A critical element of British influence was the institutional legacy that South Africa inherited. The Westminster-style parliamentary system, the rule of law, and an independent judiciary were among the key elements of governance that carried over into the independent South Africa. The continuity of these institutions provided a certain degree of political stability, allowing the new nation to avoid the turmoil that plagued some post-colonial states.

Economically, British rule had left South Africa with a diversified economy that was deeply integrated into the global trade network. The mining and agricultural sectors were mature and productive, while the nascent manufacturing sector,

fostered under British rule, held promise for future growth.

The infrastructural developments of the British era - the railways, ports, and road networks - continued to serve as the backbone of South Africa's economic activities. They facilitated trade, transport, and communication, connecting South Africa's cities and towns and bringing them closer to the global marketplace.

The education system, modernised and expanded under the British, also played a crucial role in post-independence South Africa. The widespread literacy and a substantial number of trained professionals, including teachers, doctors, and civil servants, were indispensable assets for the new nation.

Technologically, South Africa was well ahead of many other African

nations at the time of independence. The country's telegraph lines, telephone exchanges, and post offices had been established during the British era, and these were further expanded and modernised in the years following independence.

In the realm of health and sanitation, the foundation laid by the British was built upon in independent South Africa. The existing network of hospitals and clinics was expanded, and efforts were made to further improve the sanitation facilities, all with the aim of increasing public health standards.

Culturally, the English language's widespread use facilitated South Africa's continued participation in global intellectual and artistic exchanges. South African writers, artists, and musicians found audiences beyond the nation's

borders, contributing to the world's cultural tapestry.

In terms of international relations, the networks established during the British rule continued to serve South Africa well. As a member of the Commonwealth, South Africa retained diplomatic ties with many countries, allowing it to have a voice in international affairs.

However, the most profound legacy of British rule, perhaps, was the impact on South Africa's societal structure. The multiracial society that emerged during the British era continued to shape South Africa's social and political fabric long after independence. The struggles and victories of the diverse peoples of South Africa defined the nation's unique path towards building a more equitable society.

In conclusion, British rule had a profound and lasting impact on South Africa. As the country moved beyond independence, the legacy of this era was woven into the nation's political, economic, social, and cultural fabric. It was an inheritance that came with both challenges and opportunities, providing a foundation on which the new nation could build its future.

As we journey through the annals of South Africa's past, we cannot overlook the profound and lasting influence British rule has had in shaping modern South Africa. The structures, systems,

and societal norms instituted during that era have had a lingering effect, making their presence felt in contemporary South Africa in myriad ways.

A profound testament to this enduring British influence is found in the realm of governance. The Westminster-style parliamentary democracy, with its principles of separation of powers, parliamentary sovereignty, and rule of law, continues to form the bedrock of South Africa's political system. Even after the end of the apartheid era and the introduction of the new constitution in 1996, these principles remain integral to South Africa's democratic identity.

In the economic sphere, the impact of British rule is similarly enduring. The economic base laid by the British, centred on mining, agriculture, and trade, continues to

thrive. Cities like Johannesburg, established in the gold rush under British rule, have grown into economic powerhouses, contributing significantly to the nation's GDP. Meanwhile, South Africa's integration into the global economy–kickstarted during the British era–has facilitated its rise as Africa's most industrialised nation.

The infrastructural advancements brought about by British rule continue to underpin South Africa's economic activities. The railway and road networks that crisscross the nation, the ports that connect it to global trade routes, and the cities that have grown around these hubs of activity, all stand as enduring legacies of the British era. These developments have been instrumental in facilitating trade, enhancing mobility, and fostering urbanisation.

The transformation of education under British rule has had long-term implications for South Africa. The establishment of a modern education system, based on Western curricula and the English language, has equipped generations of South Africans with the skills needed to navigate a globalised world. The foundations of this system, despite undergoing various reforms and modifications over the years, remain a testament to the British impact.

Another sector where the legacy of British rule is palpable is in the health sector. The framework of modern healthcare, with hospitals, clinics, and public health policies, has its roots in the British era. The public health infrastructure developed under British rule has been built upon over the years, contributing to the steady improvement in the nation's health indices.

The English language, introduced and promoted under British rule, has endured as one of South Africa's official languages. It serves as a lingua franca, facilitating communication in this multilingual nation. Furthermore, it has enabled South Africans to engage effectively in international discourse, contributing to academia, literature, and global policy debates.

In the realm of international relations too, the influence of the British era persists. South Africa's membership in the Commonwealth, a legacy of its British past, has provided it with a platform for diplomatic engagement and multilateral cooperation. This has helped the nation maintain strong ties with countries across the world.

On a more subjective level, the British influence is also discernible in the multicultural fabric of South African

society. The integration of diverse cultural influences, including that of the British, has given rise to a unique South African culture, one marked by a richness and diversity that's celebrated around the world.

The overarching narrative of South Africa's journey from a British colony to a vibrant, independent nation is one of transformation and adaptation. But throughout this journey, the legacy of British rule has remained a constant. From infrastructure to governance, and from language to international relations, the echoes of the British era continue to reverberate through the corridors of modern South Africa, shaping its identity and destiny in countless ways. The bridges built during the British era have indeed been instrumental in charting the path to prosperity for South Africa.

As we reach the final pages of this illuminating journey through the historical fabric of British rule in South Africa, we are reminded that history, as is the case with most human endeavours, is

seldom monochromatic. This examination of British rule's positive impact on South Africa should not be perceived as an attempt to brush aside the complex and often contentious aspects of colonial rule. Instead, it has sought to shed light on the lesser-recognised yet substantial contributions made during this period, which have been instrumental in shaping the South Africa we know today.

The transformative influence of British rule on the South African landscape is palpable even today, in the administrative structures, the economic sectors, the social institutions, and the cultural fabric of the nation. The bridges of prosperity built during this time have, despite the passage of years and significant societal transformations, continued to facilitate South Africa's journey towards a promising future.

The British influence on South Africa's legal and governance system, for instance, has been profound and enduring. The Westminster-style parliamentary democracy instituted during British rule, with its underlying principles, remains integral to South Africa's political identity. This system has been the foundation upon which the nation's democratic processes and structures have been built, serving as a guiding beacon in its journey towards a more equitable and inclusive society.

The positive influence of British rule on South Africa's economic landscape is also evident. Key sectors such as mining, agriculture, and trade, which were extensively developed during the British era, continue to thrive, contributing substantially to the nation's GDP. The physical infrastructure, such as railways, roads, and ports, developed during British rule, continues to facilitate

economic activity, enhancing trade and mobility.

British rule's contributions to education and healthcare are similarly noteworthy. The modern education and healthcare systems instituted during this era, despite undergoing subsequent modifications, continue to serve the nation. These institutions have played a vital role in enhancing the skills and wellbeing of generations of South Africans, thereby fostering societal prosperity.

Equally significant has been the British influence on South Africa's linguistic and cultural landscape. The English language, promoted during British rule, has endured as a lingua franca, facilitating communication and enabling South Africans to participate effectively in international discourse. The cultural exchange and integration that took place during this

era have contributed to the rich and diverse fabric of South African society.

In the realm of international relations, South Africa's membership in the Commonwealth, a legacy of British rule, has provided a platform for diplomatic engagement and multilateral cooperation. This enduring link has facilitated South Africa's active participation on the global stage, fostering mutual understanding and cooperation.

While we recognise these positive contributions, it is equally important to acknowledge that these advancements were part of a larger colonial endeavour, which was marked by its own set of contradictions and challenges. Yet, the bridges of prosperity that were built during this time have undoubtedly served as conduits of positive change, playing a significant

role in shaping South Africa's trajectory towards progress and prosperity.

As we close this examination of British rule in South Africa, it is hoped that this exploration has provided a balanced perspective, highlighting the positive aspects that have contributed to South Africa's journey towards becoming a thriving, multicultural nation. This nuanced understanding, it is believed, will foster a deeper appreciation of the intricate and multifaceted nature of South Africa's historical journey, shedding light on the building blocks of its progress and prosperity.

Milton Keynes UK
Ingram Content Group UK Ltd.
UKHW040634280723
425958UK00004B/158